Patterning Techniques

A pattern is a repetition of shapes and lines that can be simple or complex depending on your preference and the space you want to fill. Even complicated patterns start out very simple with either a line or a shape.

Repeating shapes (floating)

Shapes and lines are the basic building blocks of patterns. Here are some example shapes that we can easily turn into patterns:

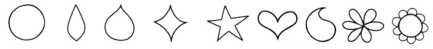

Before we turn these shapes into patterns, let's spruce them up a bit by outlining, double-stroking (going over a line more than once to make it thicker), and adding shapes to the inside and outside.

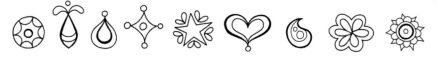

To create a pattern from these embellished shapes, all you have to do is repeat them, as shown below. You can also add small shapes in between the embellished shapes, as shown.

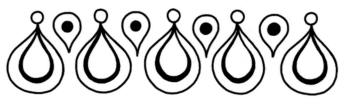

These are called "floating" patterns because they are not attached to a line. These floating patterns can be used to fill space anywhere and can be made big or small, short or long, to suit your needs.

Tip

If you add shapes and patterns to these coloring pages using pens or markers, make sure the ink is completely dry before you color on top of them; otherwise, the ink may smear.

Coloring Techniques & Media

My favorite way to color is to combine a variety of media so I can benefit from the best that each has to offer. When experimenting with new combinations of media, I strongly recommend testing first by layering the colors and media on scrap paper to find out what works and what doesn't. It's a good idea to do all your testing in a sketchbook and label the colors/brands you used for future reference.

Markers & colored pencils

Smooth out areas colored with marker by going over them with colored pencils. Start by coloring lightly, and then apply more pressure if needed.

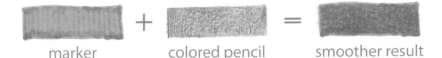

marker + colored pencil = smoother result

Test your colors on scrap paper first to make sure they match. You don't have to match the colors if you don't want to, though. See the cool effects you can achieve by layering a different color on top of the marker below.

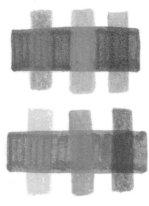

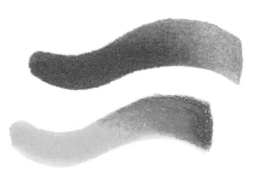

Markers (horizontal) overlapped with colored pencils (vertical).

Purple marker overlapped with white and light blue colored pencils. Yellow marker overlapped with orange and red colored pencils.

Markers & gel pens

Markers and gel pens go hand in hand, because markers can fill large spaces quickly, while gel pens have fine points for adding fun details. White gel pens are especially fun for drawing over dark colors, while glittery gel pens are great for adding sparkly accents.

Color Theory

Check out this nifty color wheel. Each color is labeled with a P (primary), S (secondary), or T (tertiary). The **primary colors** are red, yellow, and blue. They are "primary" because they can't be created by mixing other colors. Mixing primary colors creates the **secondary colors** orange, green, and purple (violet). Mixing secondary colors creates the **tertiary colors** yellow-orange, yellow-green, blue-green, blue-purple, red-purple, and red-orange.

Working toward the center of the six large petals, you'll see three rows of lighter colors, called tints. A **tint** is a color plus white. Moving in from the tints, you'll see three rows of darker colors, called shades. A **shade** is a color plus black.

The colors on the top half of the color wheel are considered **warm** colors (red, yellow, orange), and the colors on the bottom half are called **cool** (green, blue, purple).

Colors opposite one another on the color wheel are called **complementary**, and colors that are next to each other are called **analogous**.

Look at the examples and note how each color combo affects the overall appearance and "feel" of the butterfly on the next page. For more inspiration, check out the colored examples on the following pages. Refer to the swatches at the bottom of the page to see the colors selected for each piece.

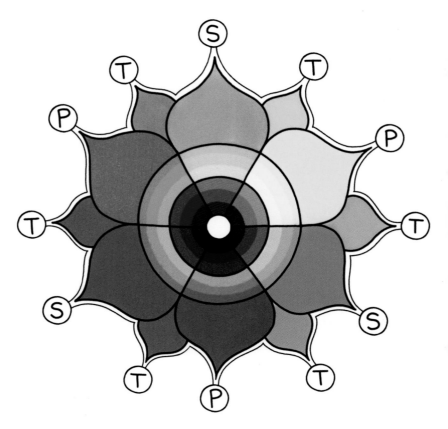

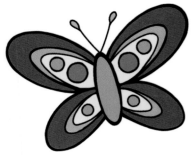

Warm colors

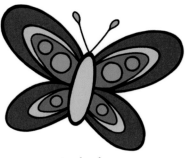

Cool colors

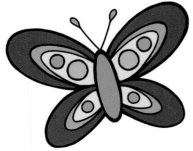

Warm colors with cool accents

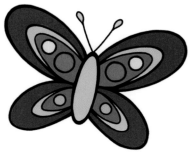

Cool colors with warm accents

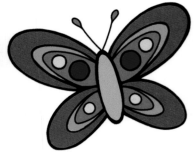

Tints and shades of red

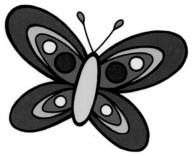

Tints and shades of blue

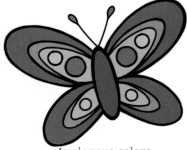

Analogous colors

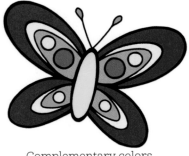

Complementary colors

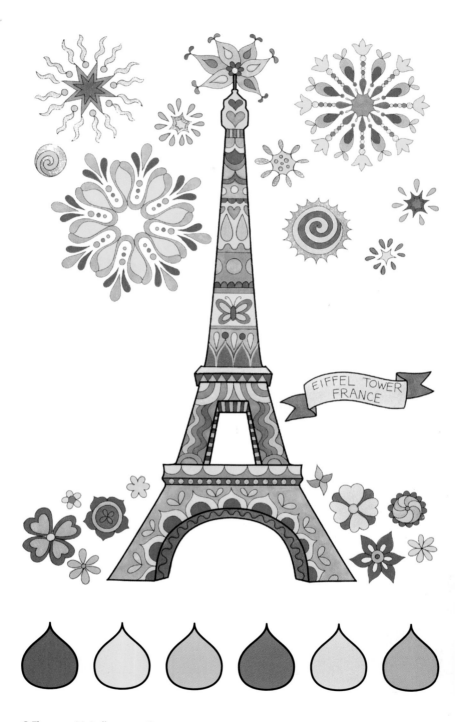

EIFFEL TOWER
FRANCE

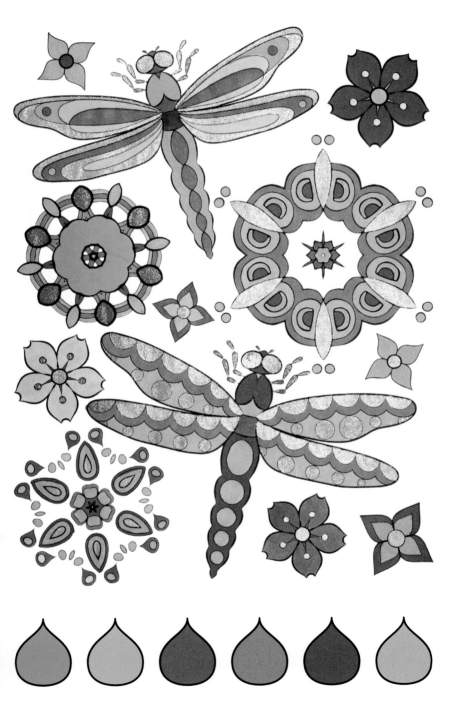

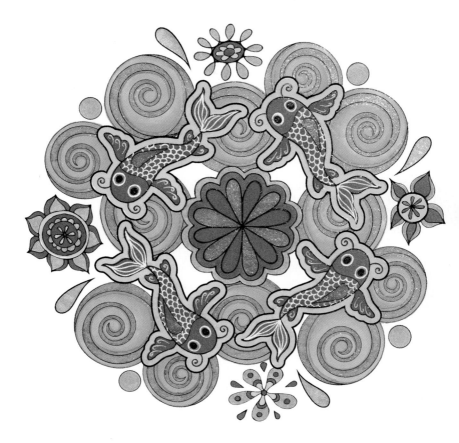

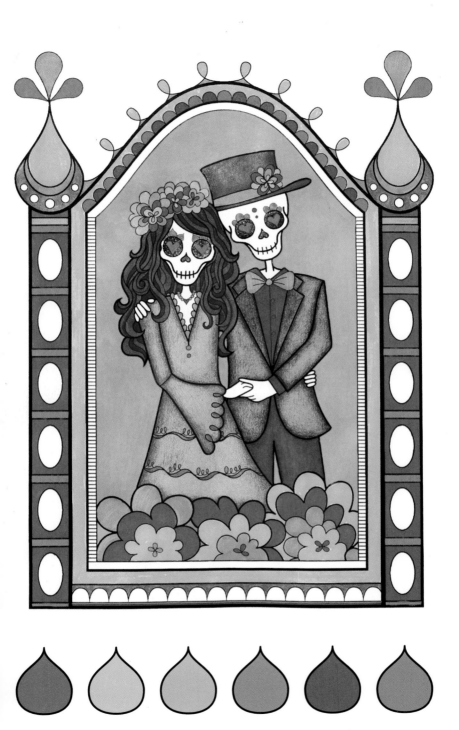

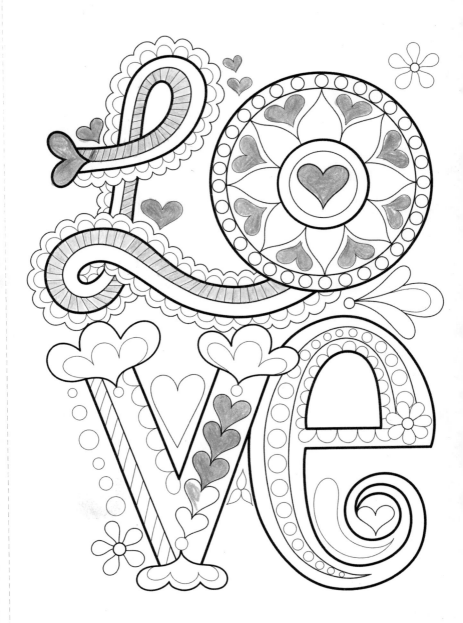

All you need is love, love
Love is all you need

—The Beatles, *All You Need Is Love*

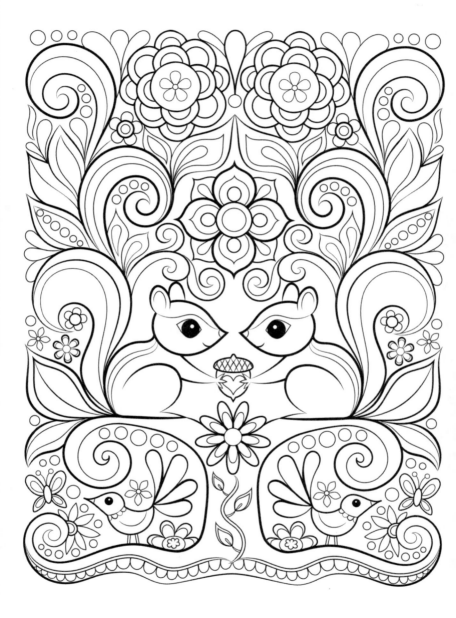

Grab your coat, leave a note,
and run away with me.

—William Chapman

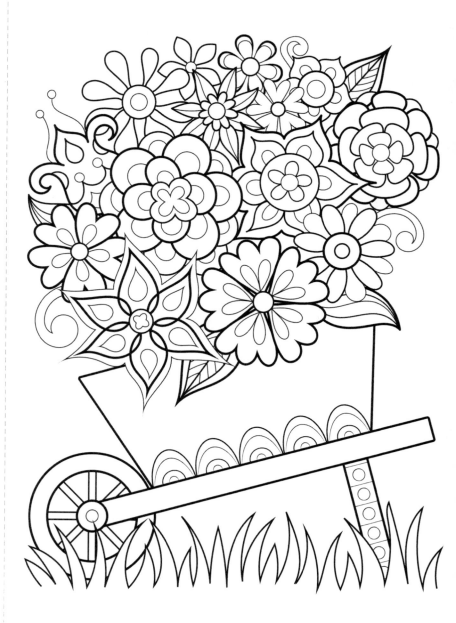

Play in the dirt, because life is too short
to always have clean fingernails.

—Unknown

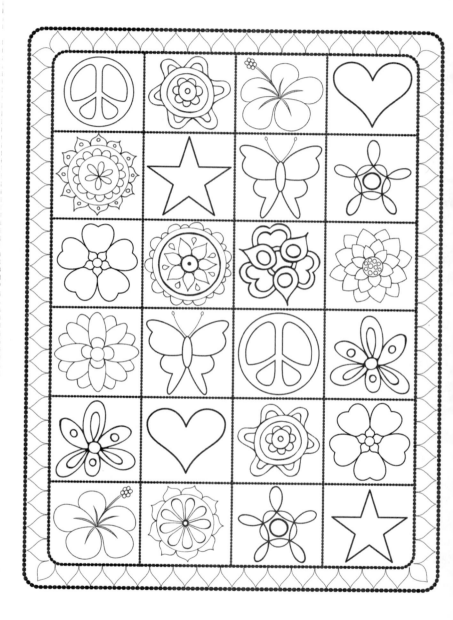

With our love, we could save the world.

—George Harrison

All I want is peace, love, and a chocolate bar
bigger than my head.

—Unknown

A house is made of walls and beams;
a home is built with love and dreams.

—Dr. William A. Ward

Painted Ladies, San Francisco, USA.
"Painted ladies" refers to Victorian or Edwardian houses
painted with three or more colors
to highlight their various architectural features.

I would rather die of passion than of boredom.

—Vincent van Gogh

Every house where love abides
And friendship is a guest,
Is surely home, and home sweet home
For there the heart can rest.

—Henry van Dyke, *A Home Song*

To live will be an awfully big adventure.

—J. M. Barrie, *Peter Pan*

Great attitudes begin with
a change of latitude.

—Unknown

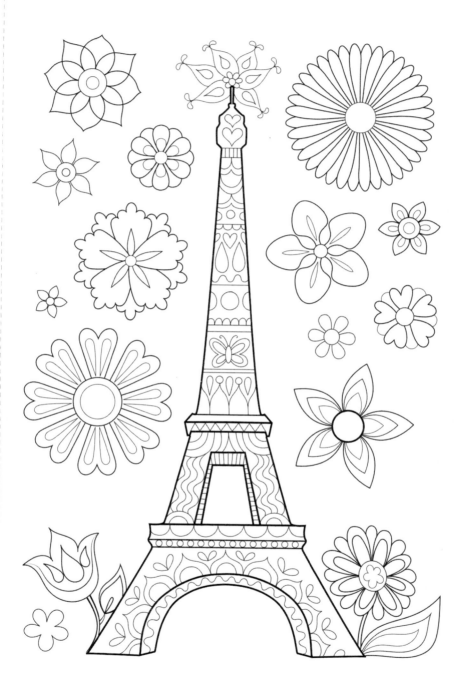

Paris is always a good idea.

—Audrey Hepburn

Eiffel Tower, Paris, France.
The Eiffel Tower is also known as *La Dame de Fer,* or "iron lady."

One love! One heart
Let's get together and feel all right.

—Bob Marley, *One Love/People Get Ready*

When you don't dress like everyone else,
you don't have to think like everyone else.

—Iris Apfel

Spread love everywhere you go;
Let no one ever come to you
without leaving happier.

—Mother Teresa

Always take the scenic route.

—Unknown

Be like the bird, who
Halting in his flight
On limb too slight,
Feels it give way beneath him,
Yet sings
Knowing he hath wings.

—Victor Hugo, "The Bird"

Where there is love there is life.

—Mahatma Gandhi

No one looks stupid when they're having fun!

—Amy Poehler

Don't think twice, it's all right.

—Bob Dylan, *Don't Think Twice, It's All Right*

Live, travel, adventure, bless, and don't be sorry.

—Jack Kerouac

C'mon people now
Smile on your brother
Everybody get together
Try to love one another right now

—The Youngbloods, *Get Together*

Nature never hurries.
Atom by atom, little by little
she achieves her work.

—Ralph Waldo Emerson

And in the end, the love you take
Is equal to the love you make

—The Beatles, *The End*

You may say I'm a dreamer
But I'm not the only one
I hope someday you'll join us
And the world will live as one

—The Beatles, *Imagine*

Life is like a camera.
Just focus on what's important,
capture the good times,
develop from the negatives,
and if things don't turn out—
take another shot.

—Unknown

Follow your bliss and the universe will open
doors where there were only walls.

—Joseph Campbell

I have a room all to myself; it is nature.

—Henry David Thoreau